How to Draw
Puppies
In Simple Steps

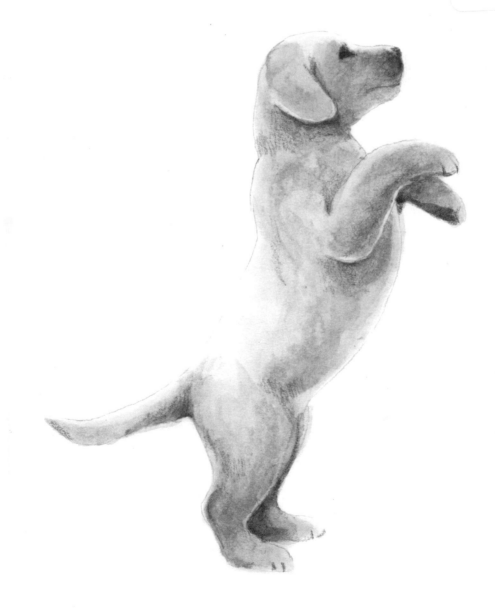

First published in 2023

Search Press Limited
Wellwood, North Farm Road,
Tunbridge Wells, Kent TN2 3DR

Text and illustrations copyright © Susie Hodge, 2023

Design copyright © Search Press Ltd. 2023

ISBN: 978-1-80092-107-8
ebook ISBN: 978-1-80093-098-8

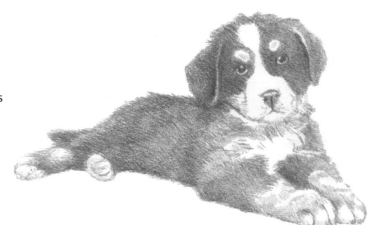

Dedication

For Max.

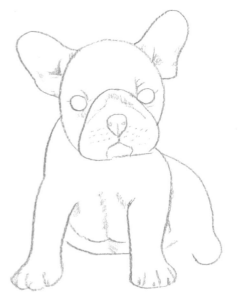

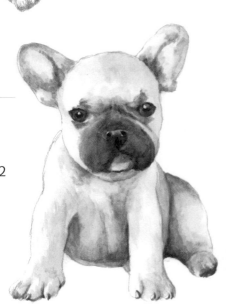

Illustrations

How to Draw
Puppies
In Simple Steps
Susie Hodge

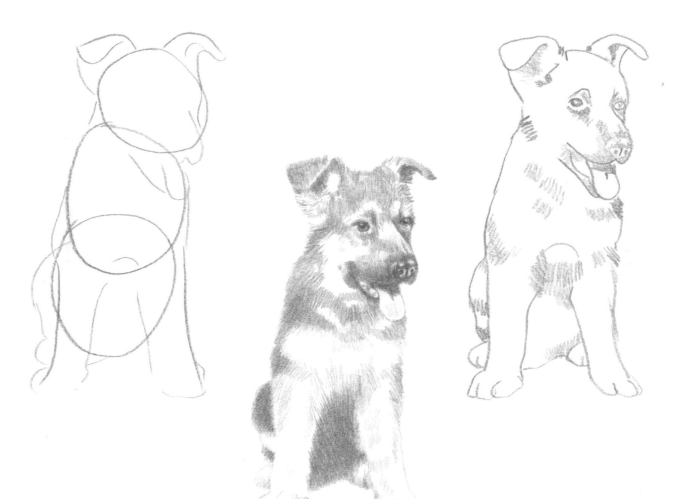

Search Press

Introduction

Welcome to a book filled with puppies! These are drawings of puppies showing personalities that we can all recognise: happy, mischievous, lively, friendly, funny, faithful – and if you follow the simple steps shown, you will soon be able to draw them all for yourself.

Each puppy is drawn in the same way, beginning with the most basic shapes and continuing for five simple stages. The fifth image on each page is a finished drawing. Everything we see can be drawn using simple lines and shapes, so the process of building up a puppy drawing from the most basic forms into a finished, detailed drawing is always the same. When any image is broken down like this, the method of drawing becomes much more straightforward.

I have used two colours for the step-by-step process so you can see when each line or mark is added. In the first step, basic initial shapes are drawn in blue, summarizing the puppy's form. Step two shows the blue lines from step one now in orange, with new marks building the image in blue, showing how to start creating a more life-like animal, for instance, linking the shapes into a more puppy-like form or outline. In step three, all previous lines are now in orange and new blue marks show where details are added such as paws, facial features and ears. In step four, some more distinguishing elements are added, including textures and tonal contrasts. The fifth stage shows the completed drawing in graphite pencil, with everything built up in light, careful pencil marks, including textures, tones, facial features and other details, which all help to convey the puppy's form and character.

When you follow these stages with your own drawings, there is no need to use coloured pencils. Choose a fairly soft graphite pencil such as a B, 2B or 3B. Keep it sharp and don't press hard, so that you can erase any mistakes along the way.

Finally, there is a watercolour painting of each puppy in its natural colours. Have a go at this too if you like – just draw a simple outline and then use whatever materials you feel comfortable with; let your paints, coloured pencils, pastels or whatever you use do the talking!

I hope you draw all the puppies in this book and then go on to draw more of your own. If you use this simple construction method, you will attain the correct proportions. To do this from life, before you draw, look at the puppy you are drawing and visualize its basic shapes and proportions – for instance, what is the size of the head compared to the body, the length of the legs in relation to the length of the head and so on? You will soon become confident in drawing and will develop your own style, which I hope will give you years of pleasure.

Keep drawing!

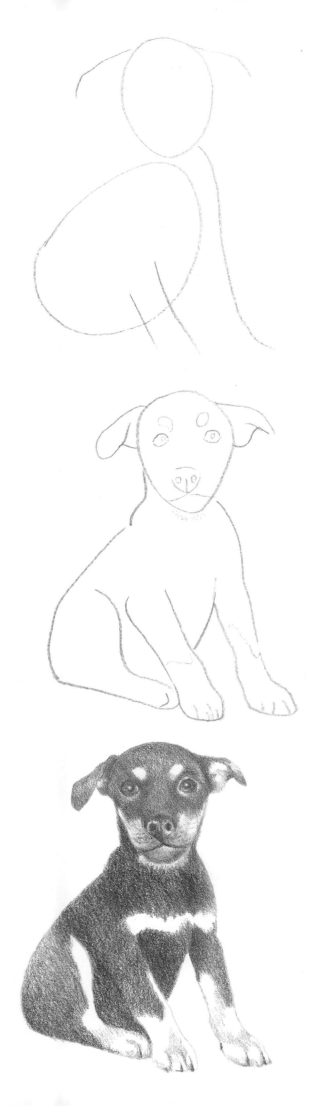
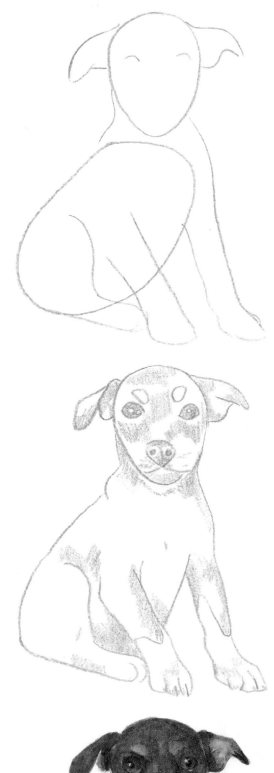
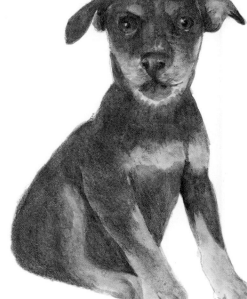

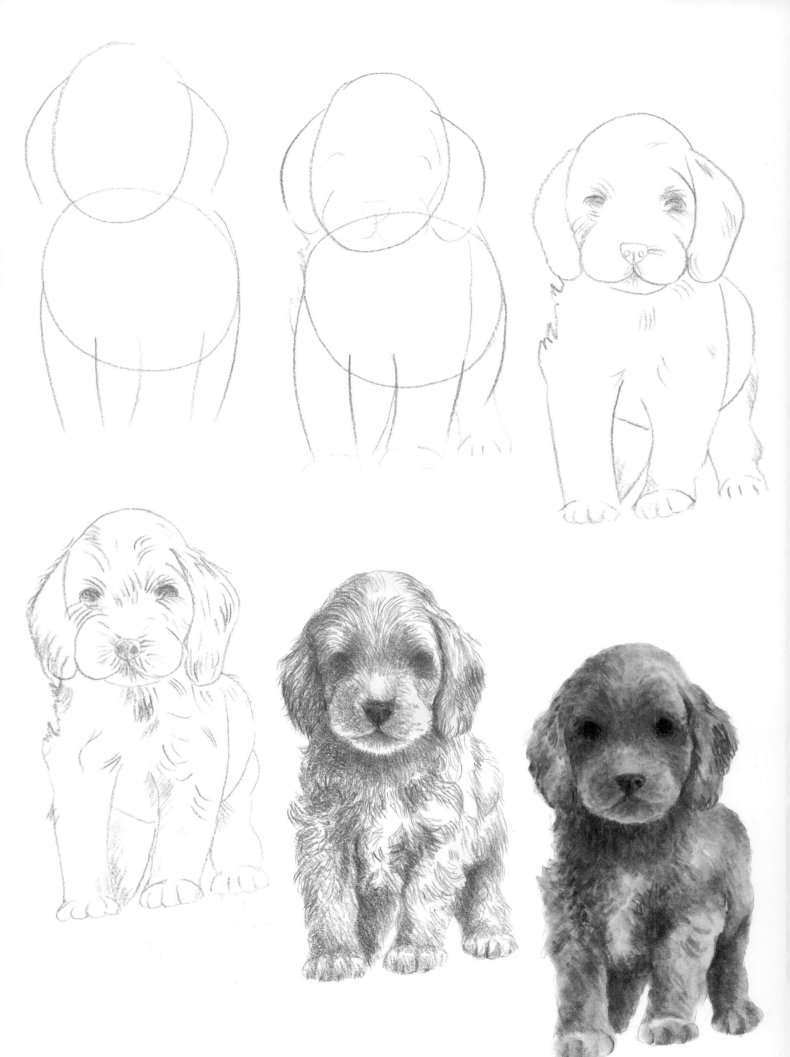

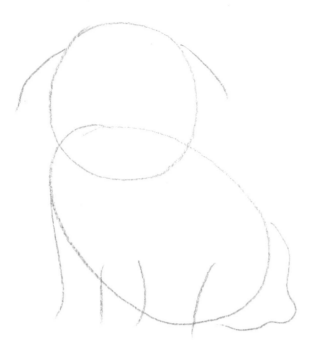

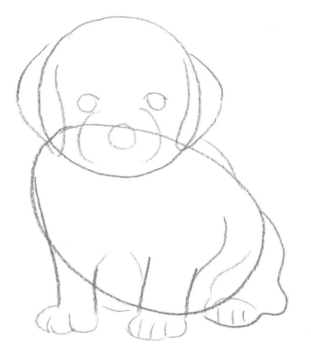

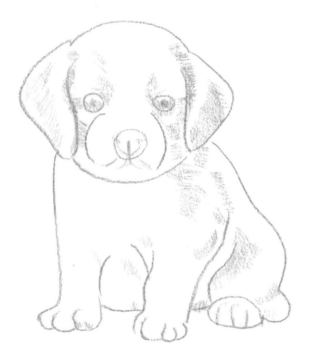

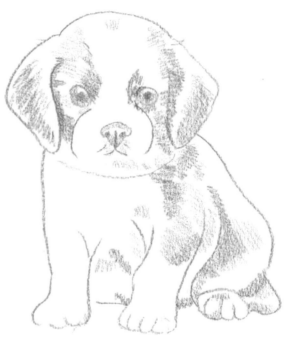

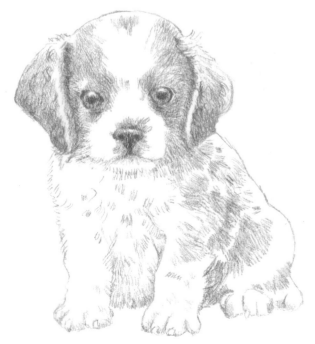

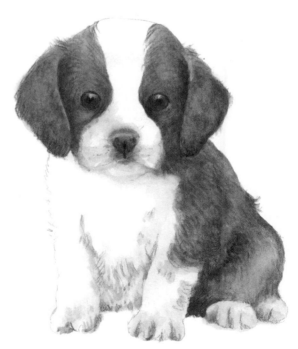

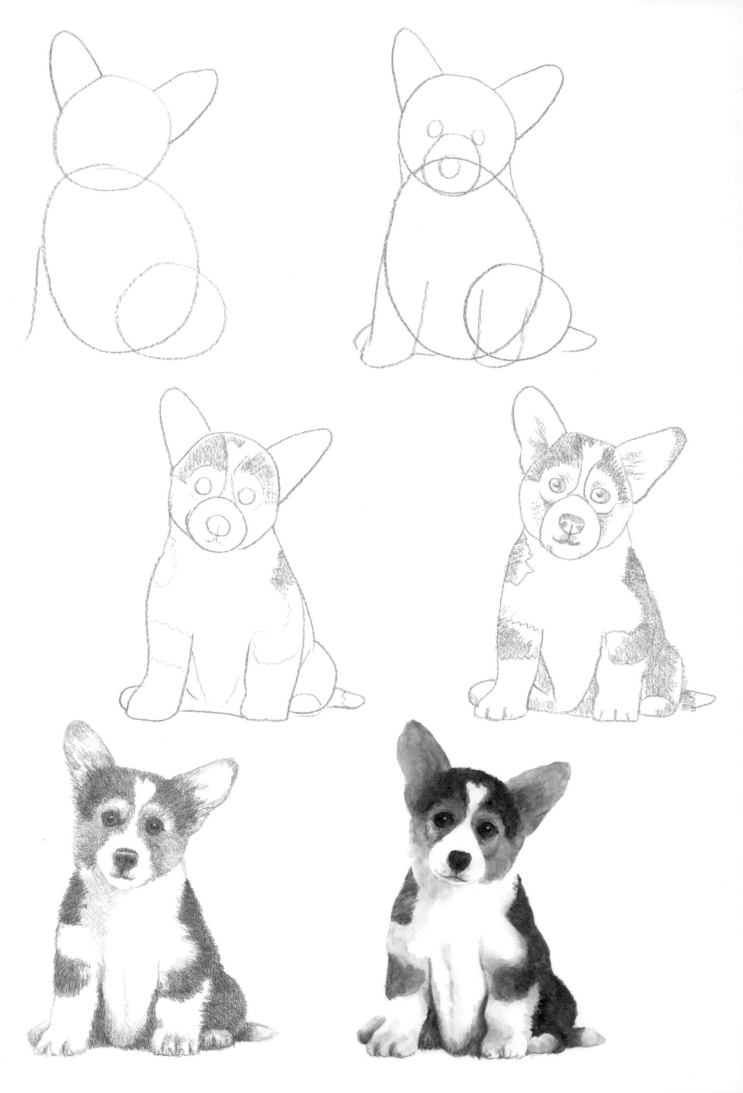

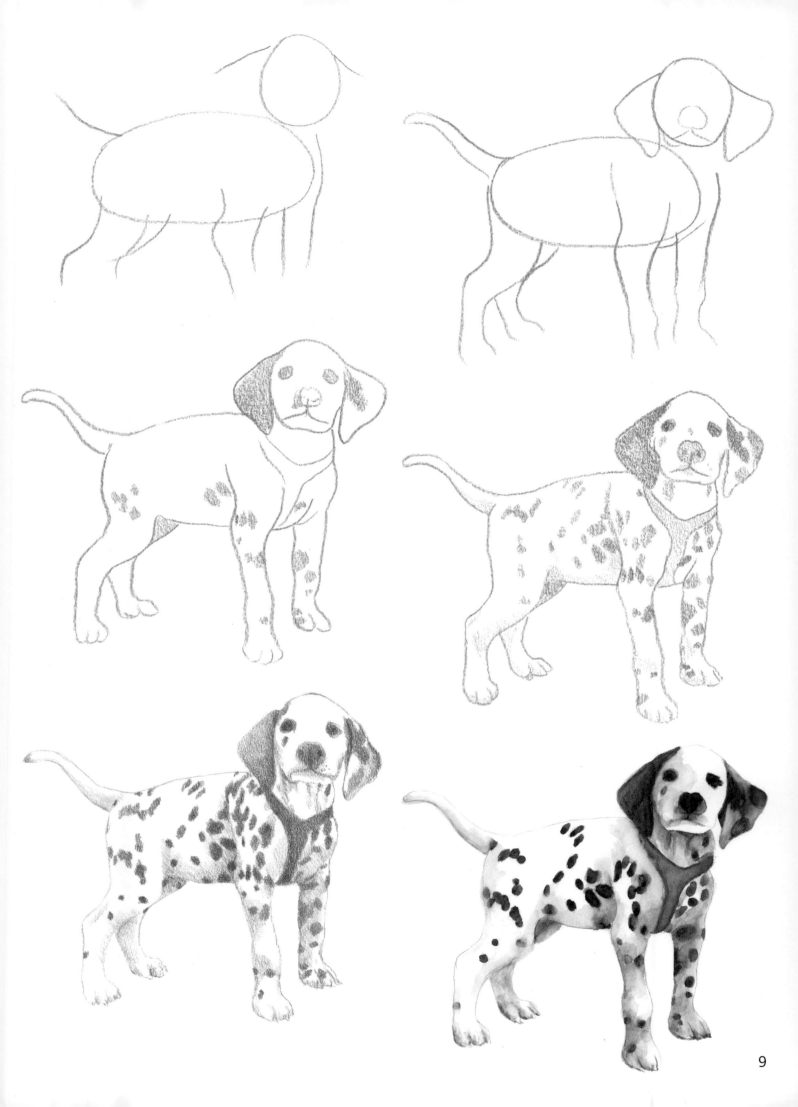

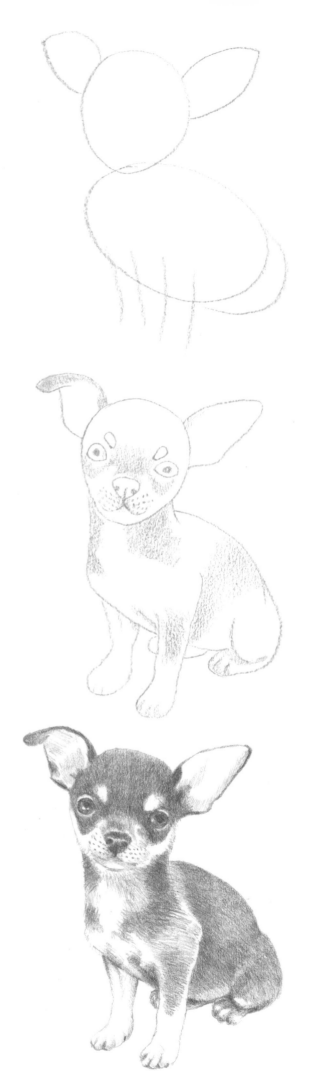
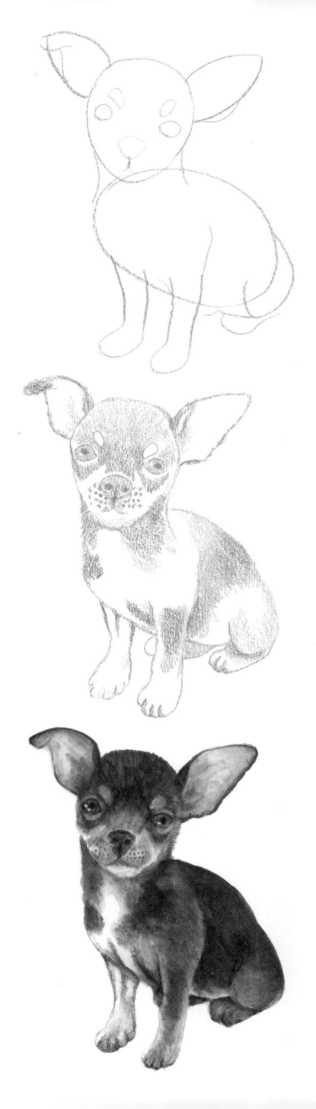

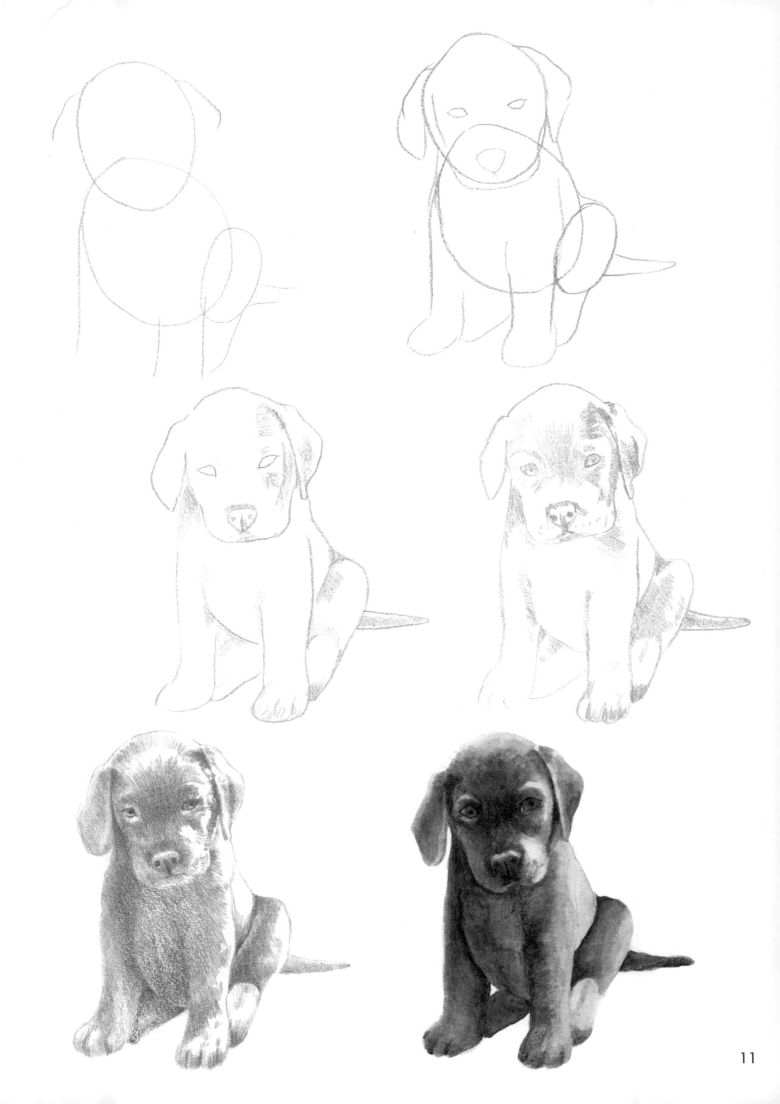

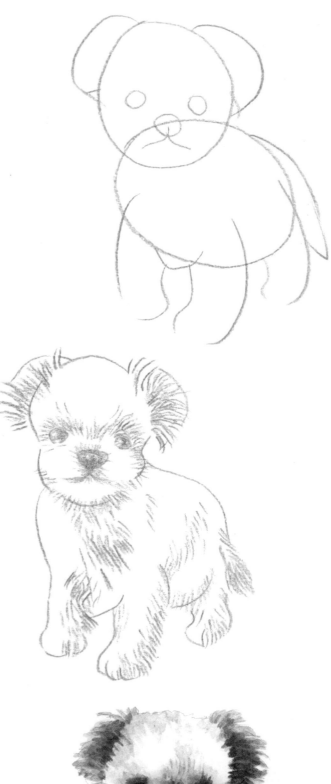
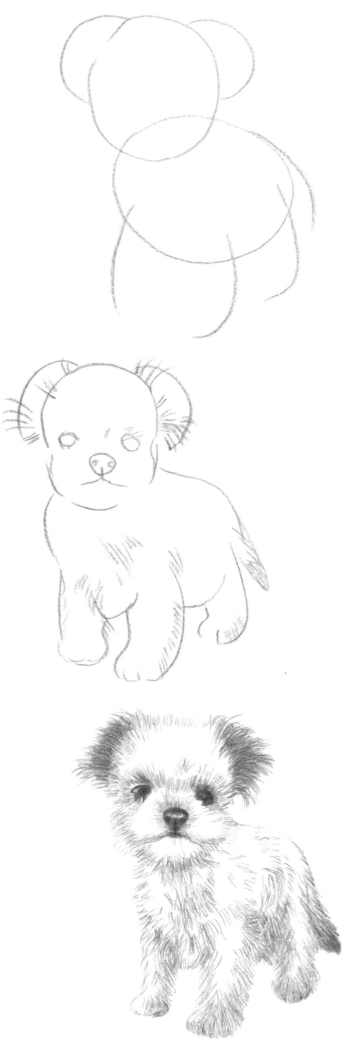
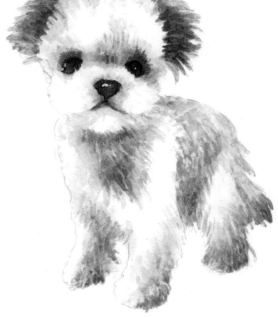

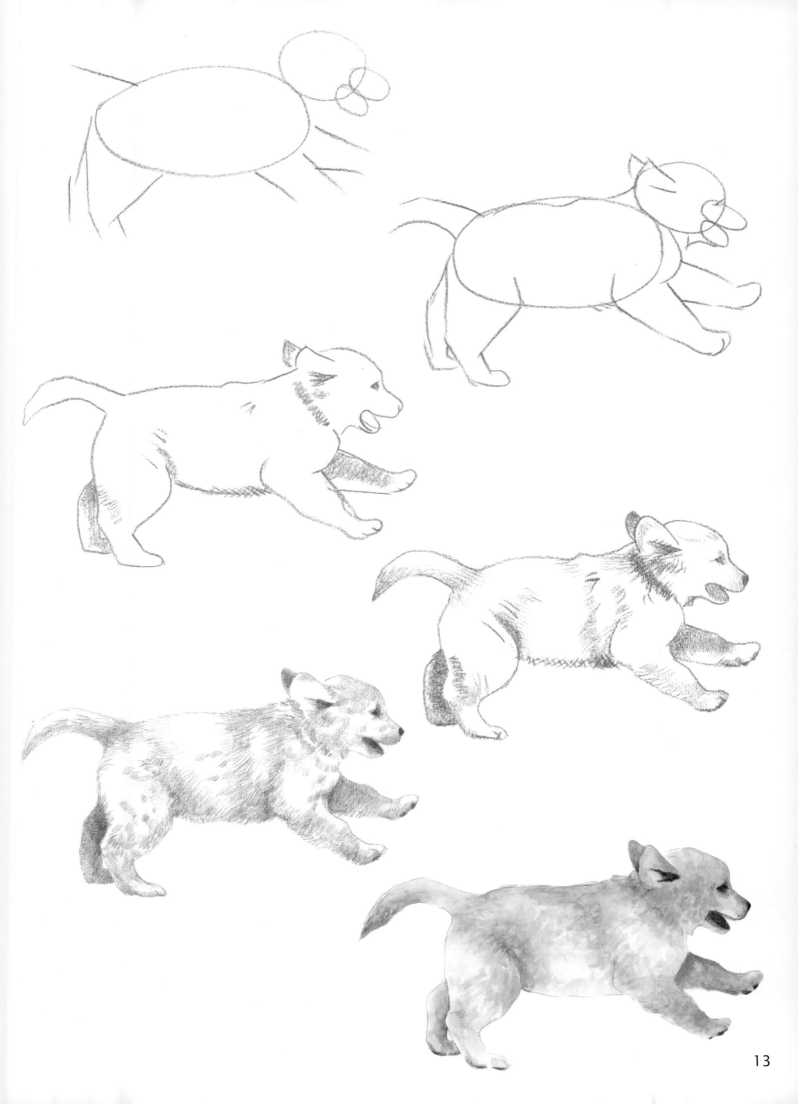

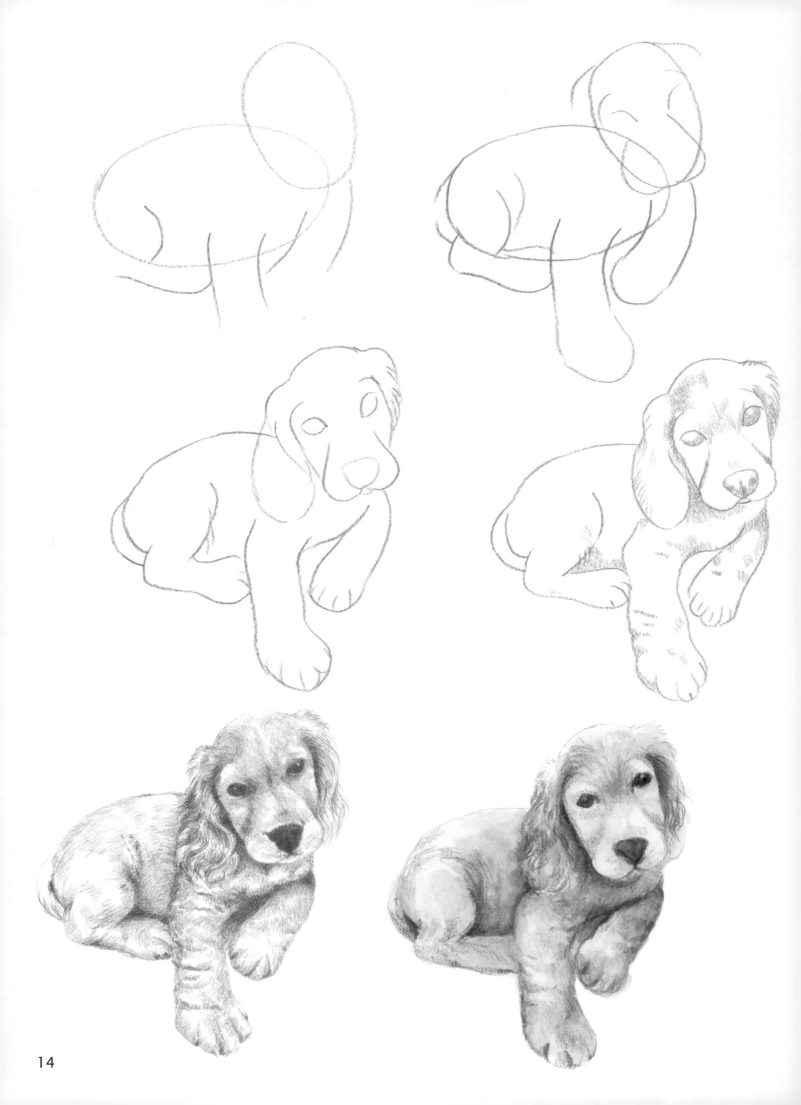

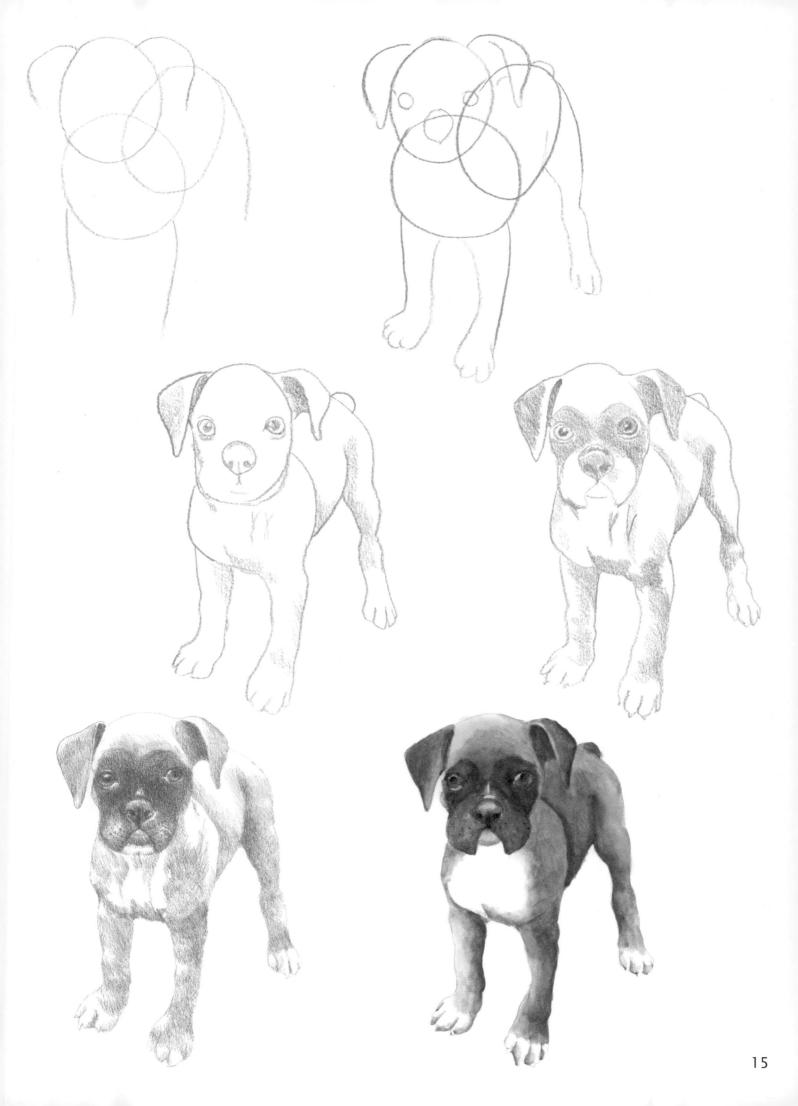

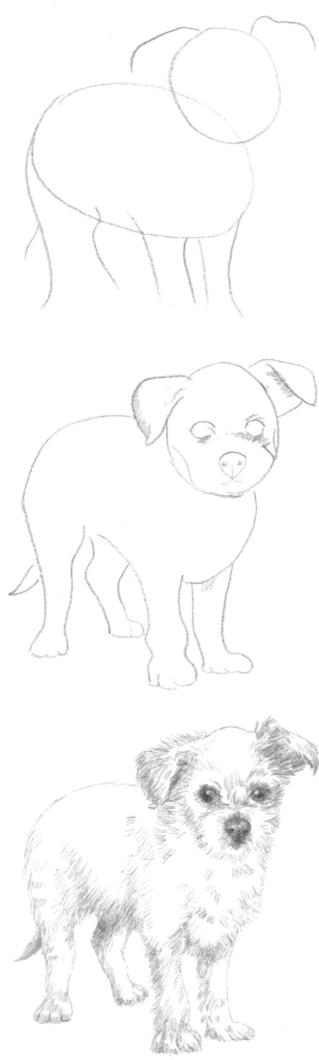
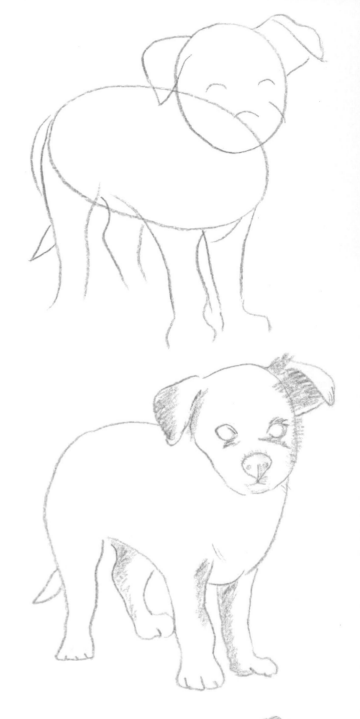
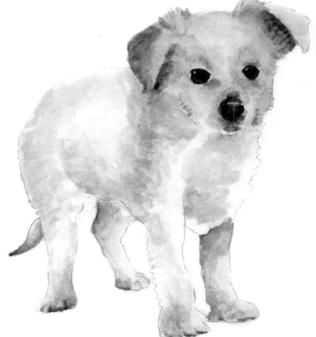

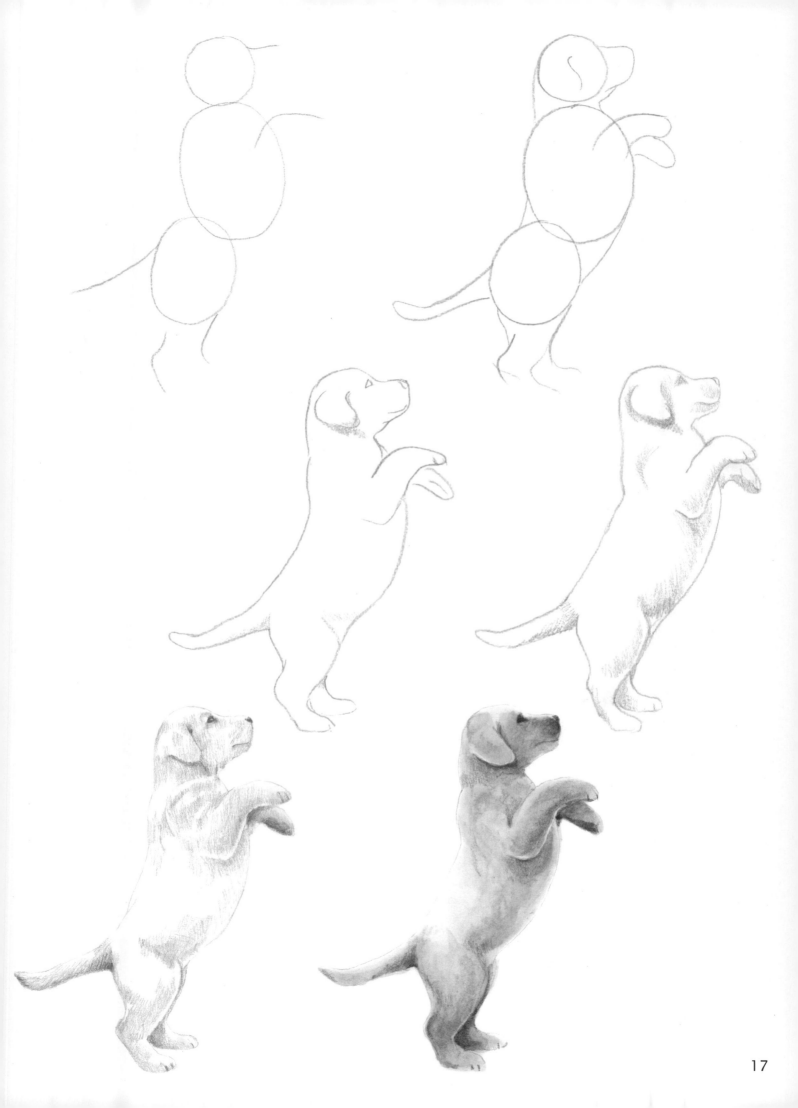

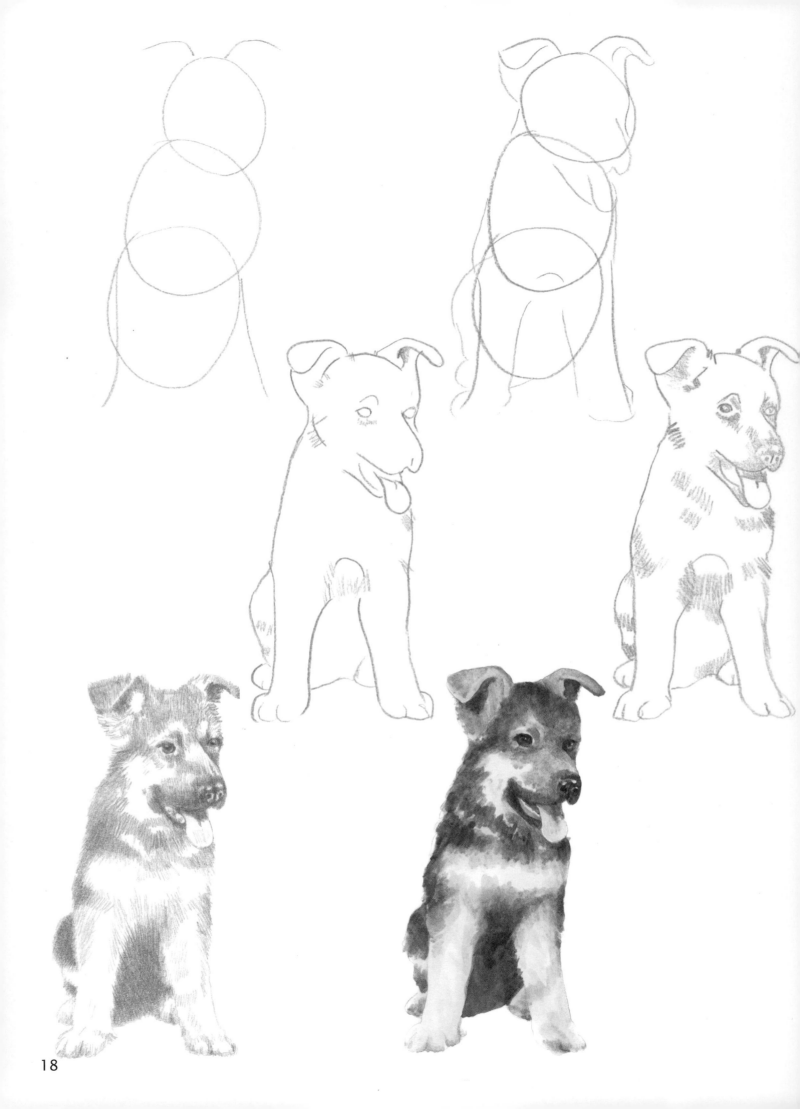

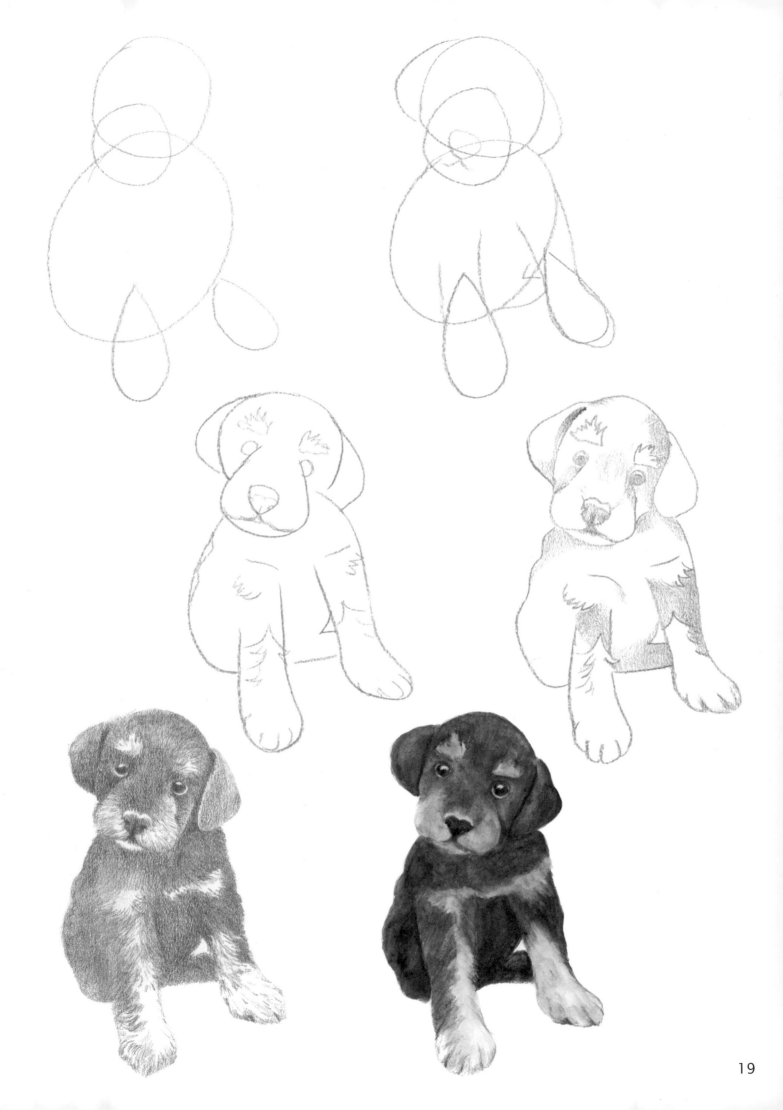

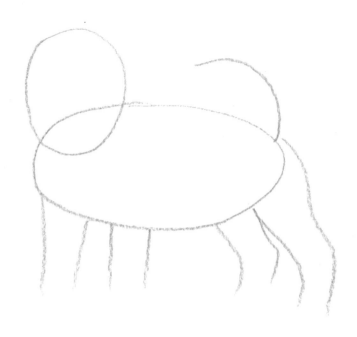

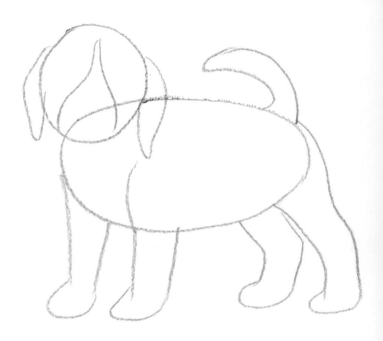

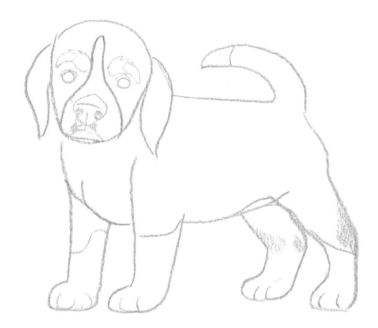

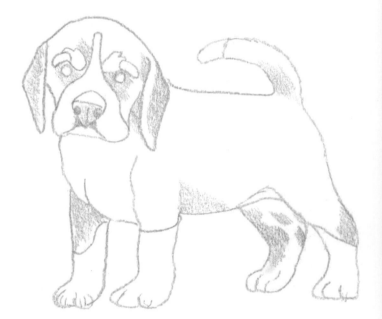

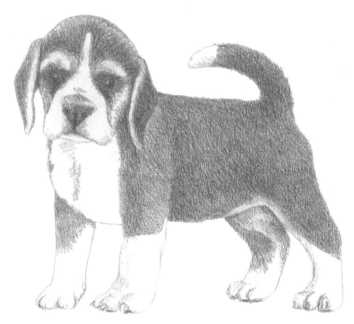

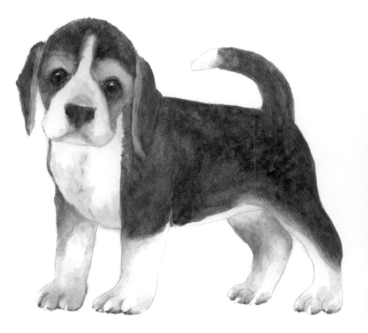

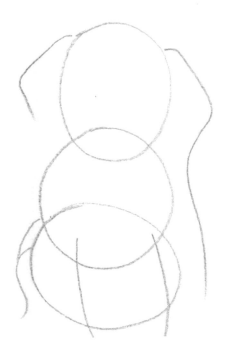
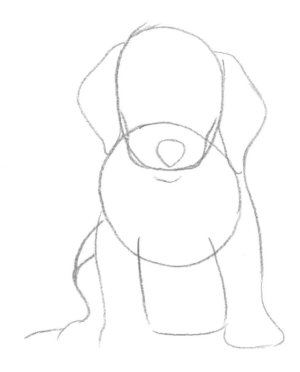
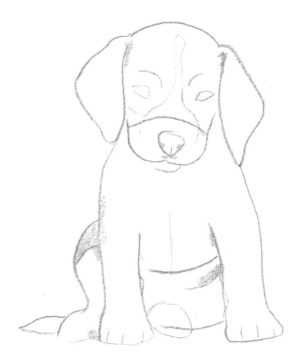
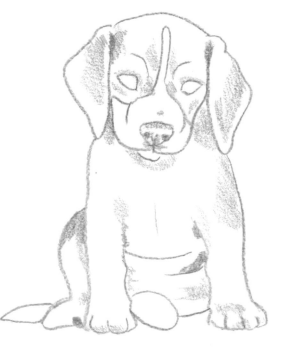
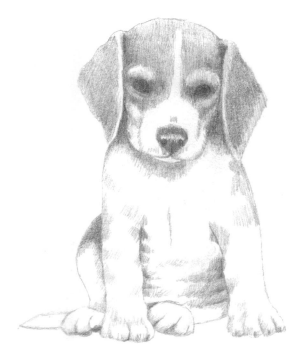
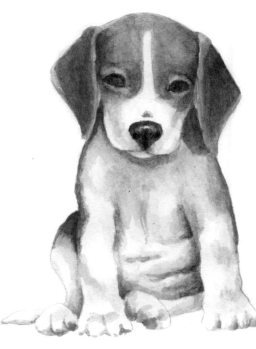

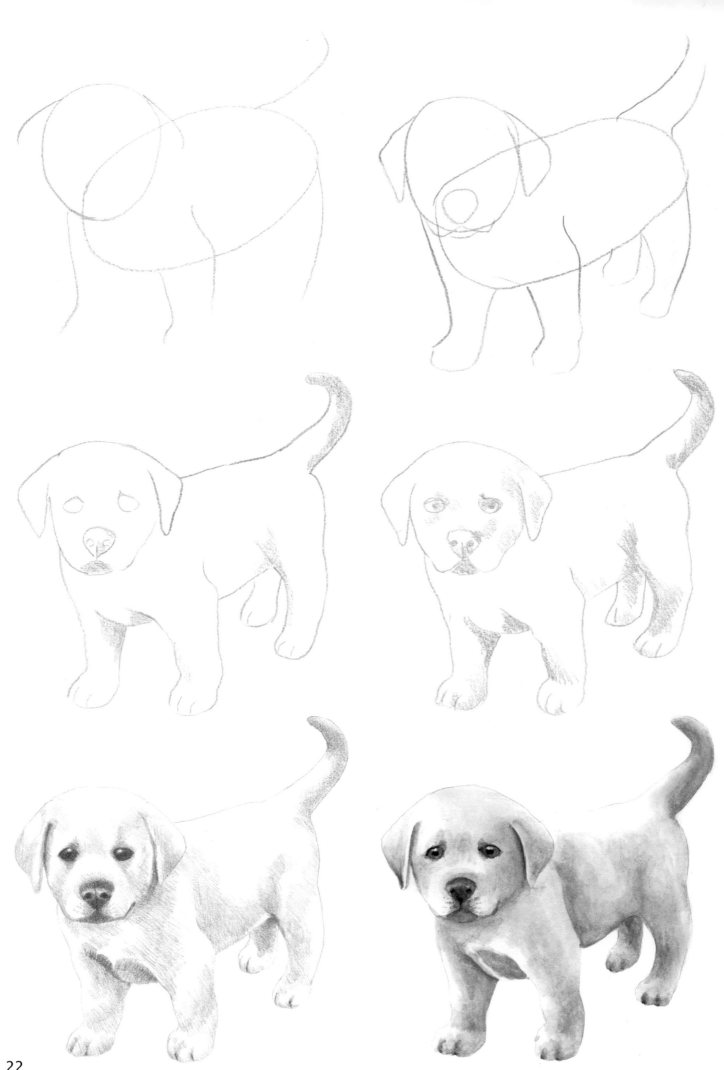

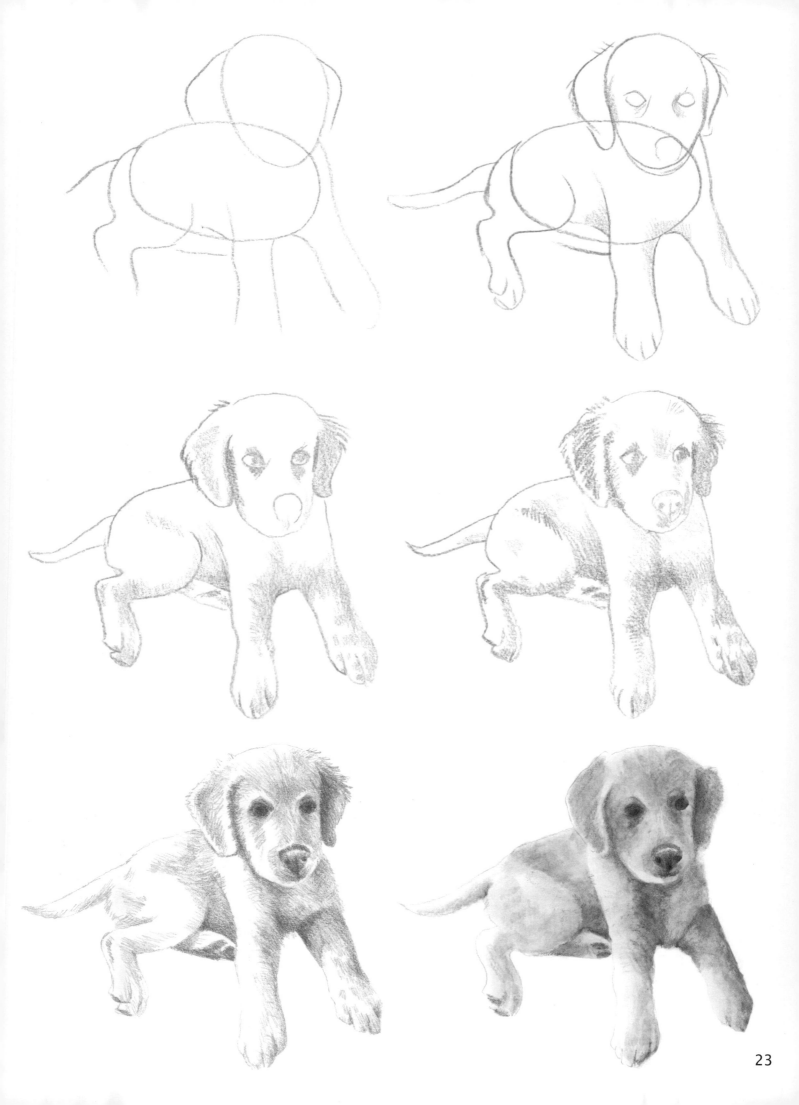

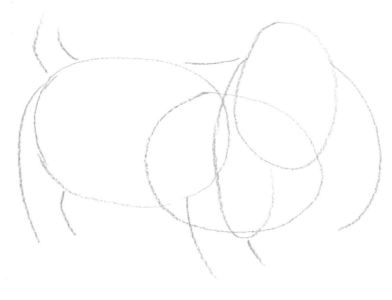

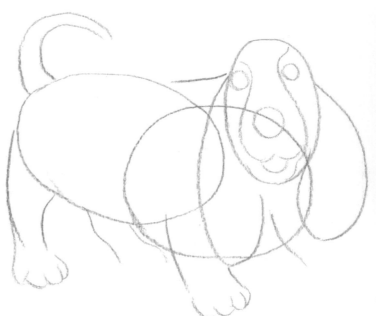

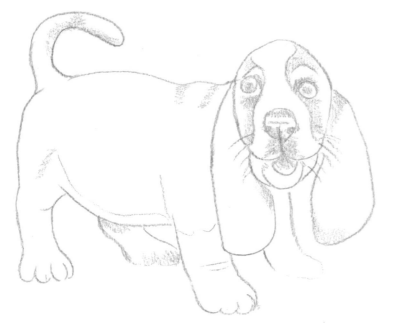

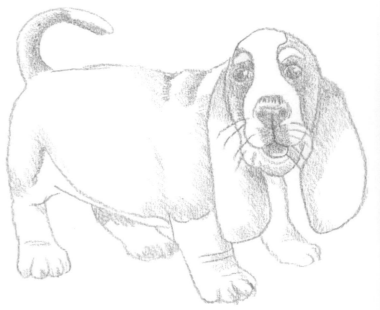

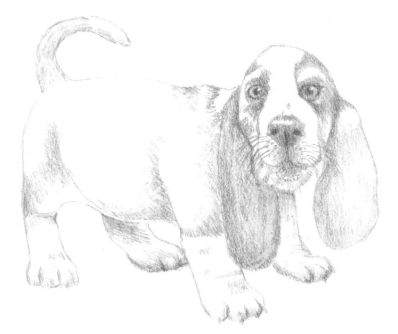

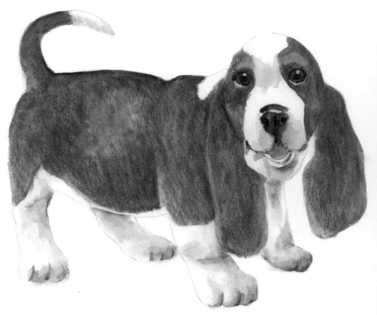

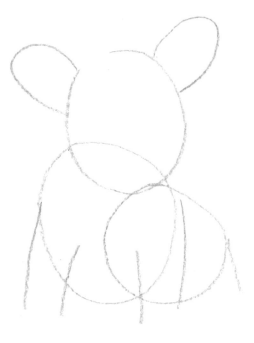

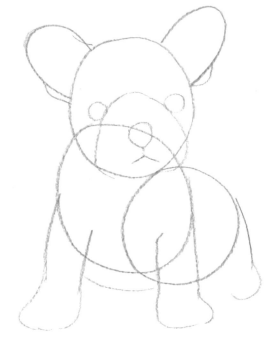

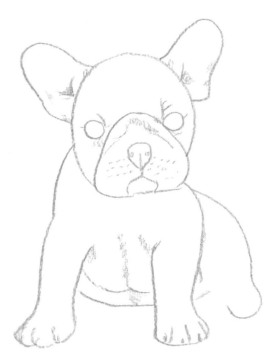

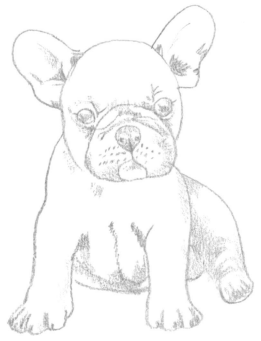

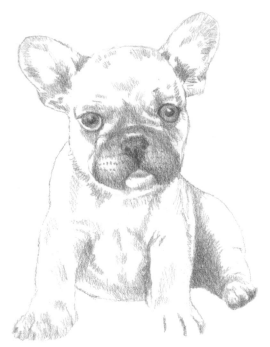

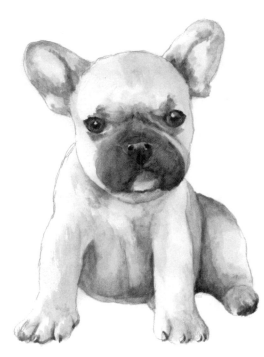

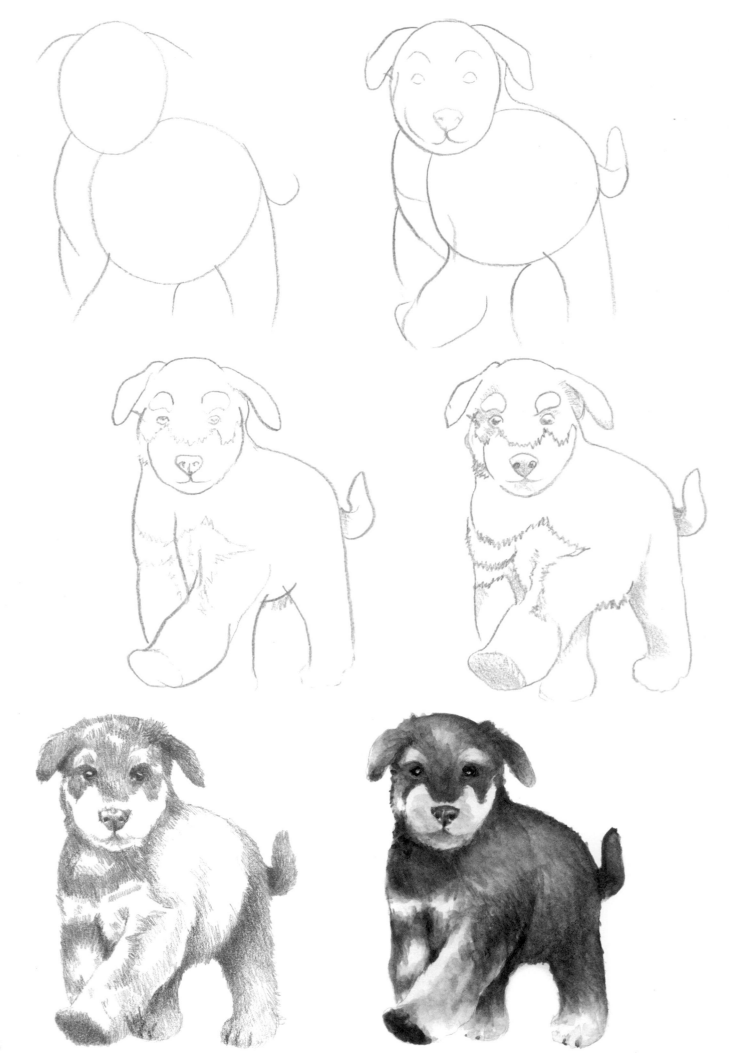

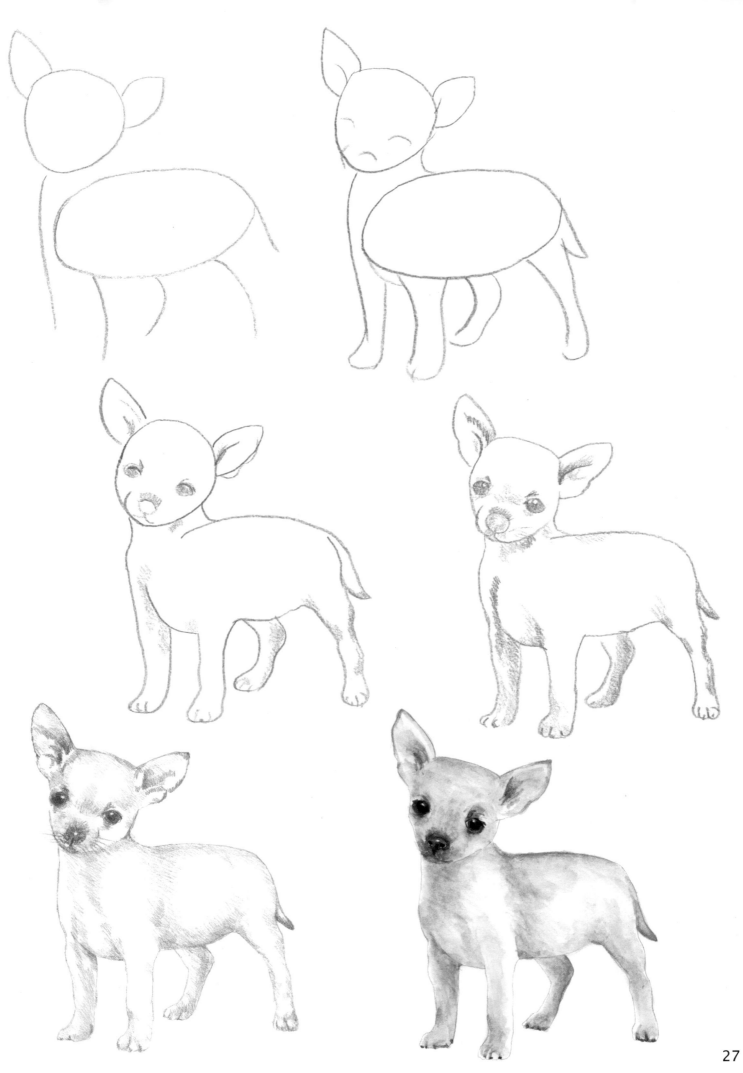

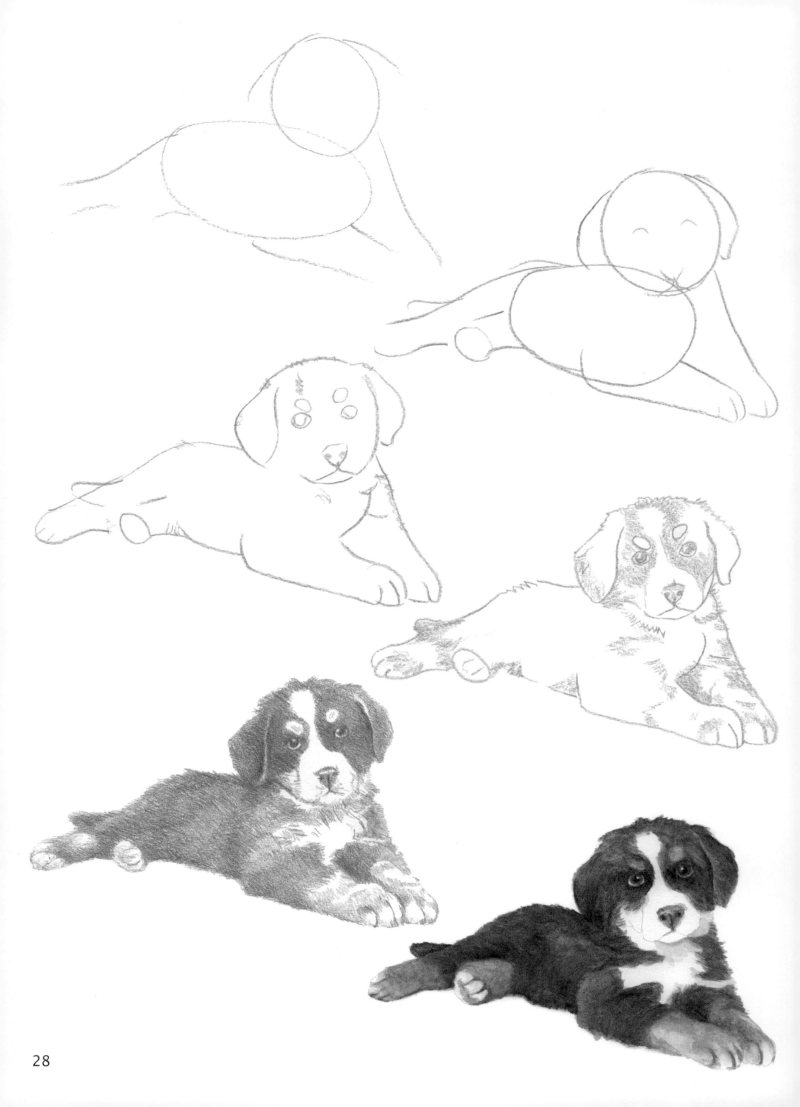

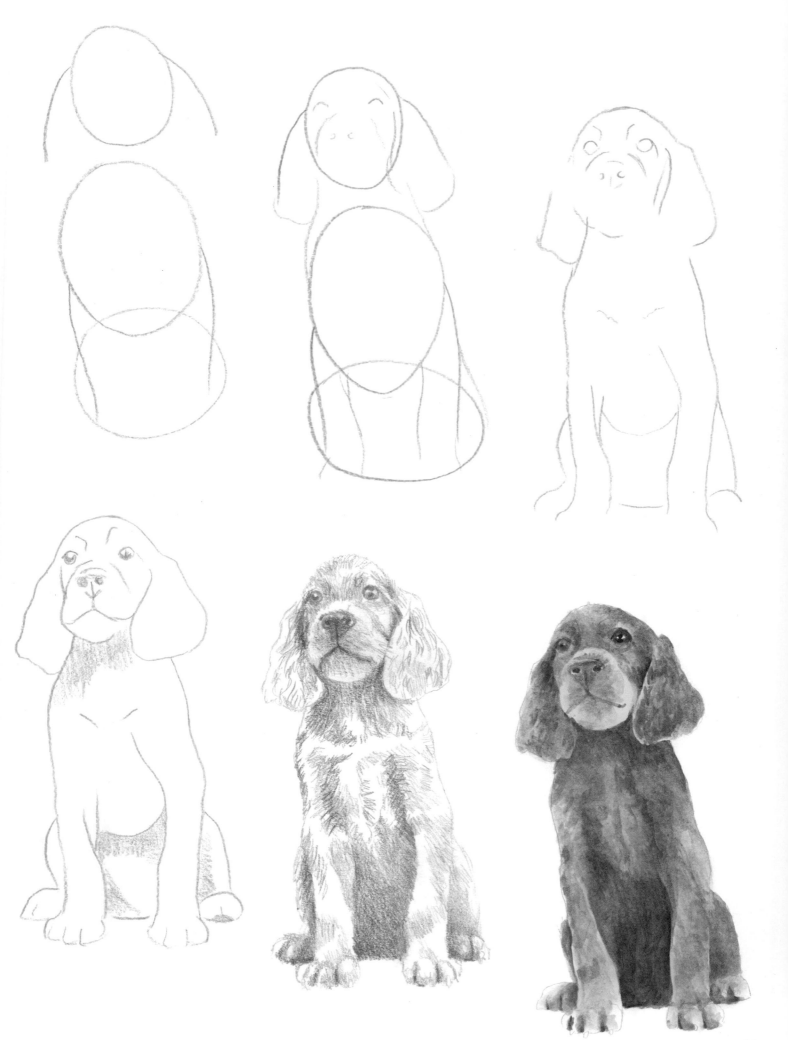

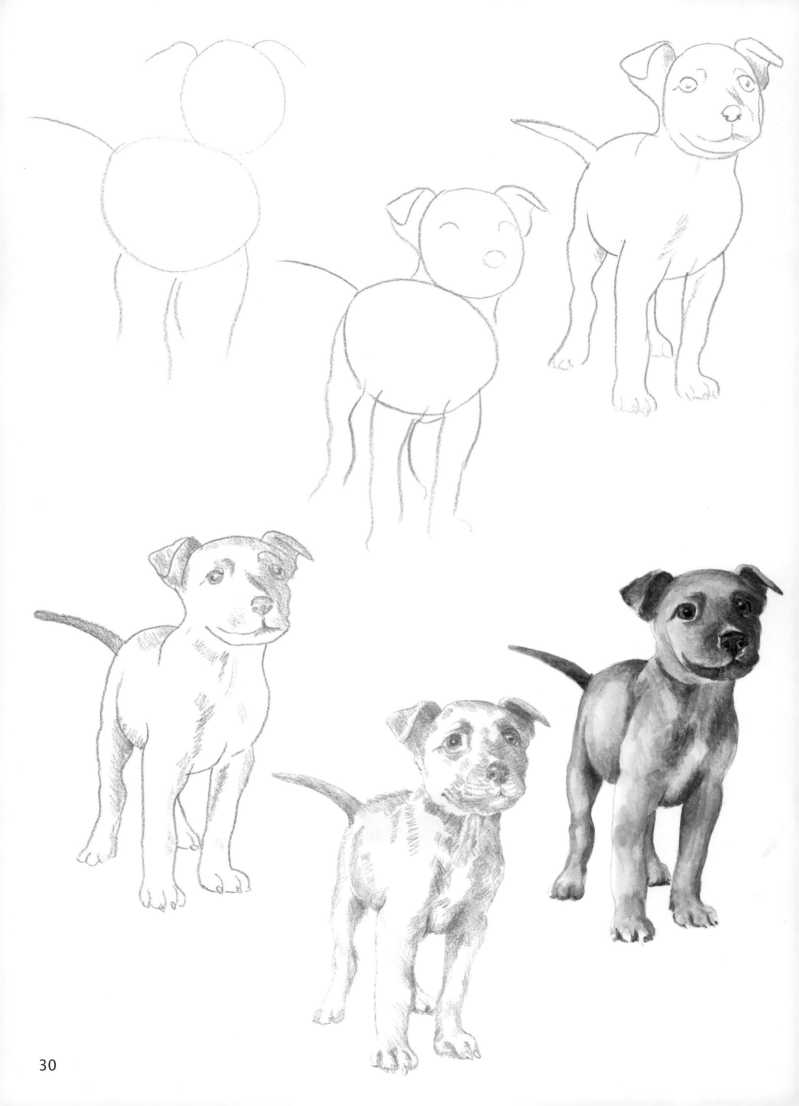

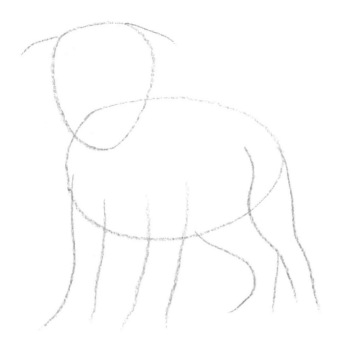
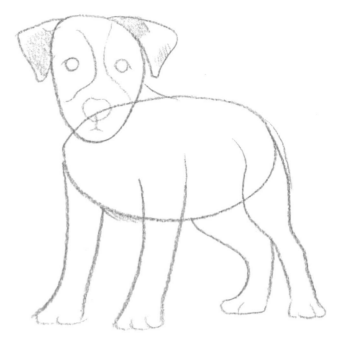
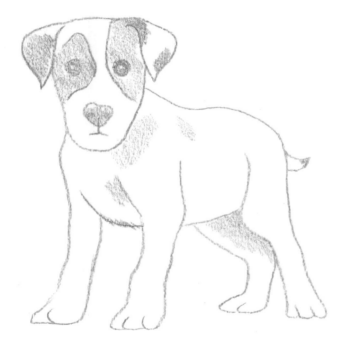
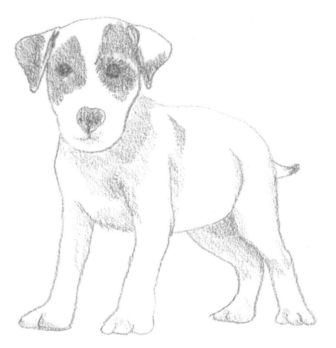
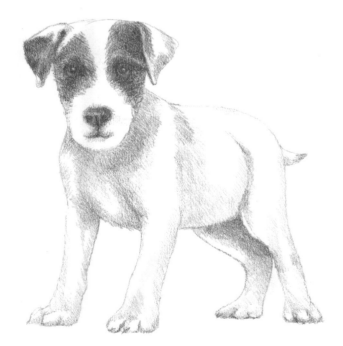
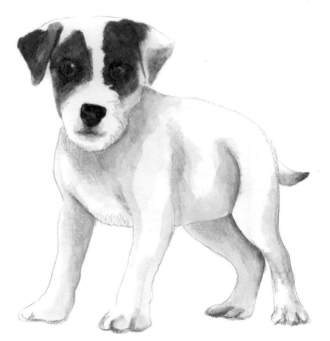

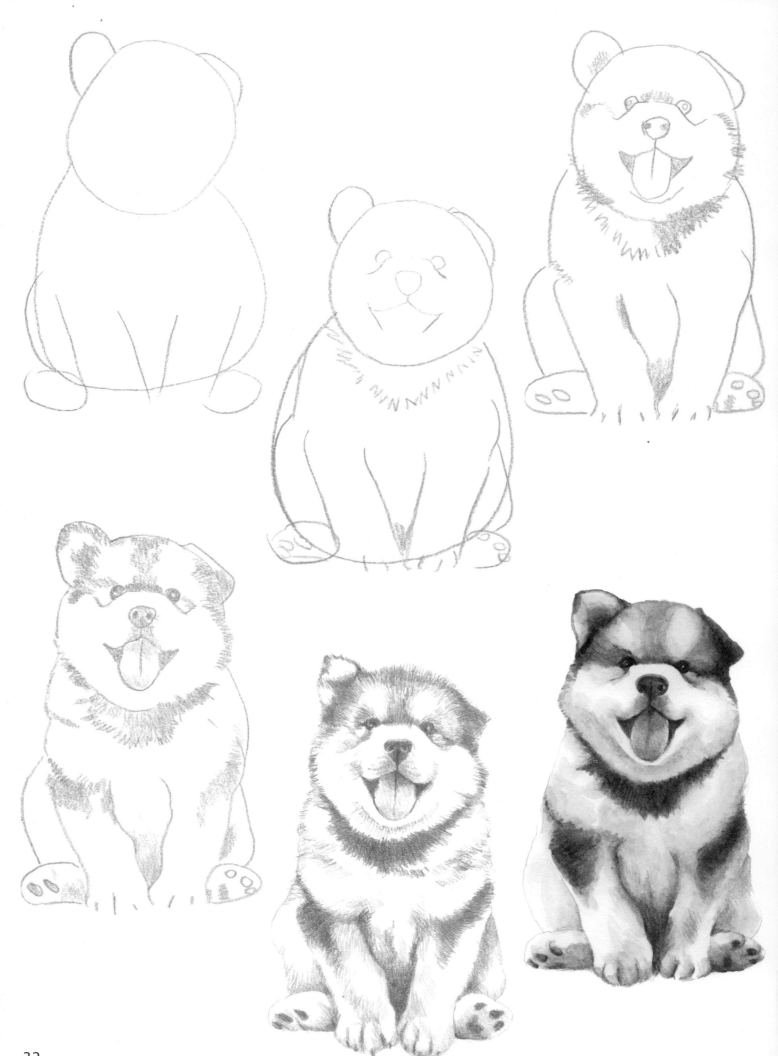